Tre... Decorative Floral Designs

Dover Publications, Inc.

Mineola, New York

Bibliographical Note

Treasury of Decorative Floral Designs is a new work, first published by Dover Publications, Inc., in 2005.

DOVER *Pictorial Archive* SERIES

Library of Congress Cataloging-in-Publication Data

Treasury of decorative floral designs / Dover.
 p. cm.—(Dover pictorial archive series)
 ISBN 0-486-44623-9 (pbk.)
 1. Decoration and ornament—Plant forms. I. Dover Publications, Inc. II. Series.

NK1560.T74 2005
743'.7—dc22

 2005047221

Manufactured in the United States of America
Dover Publications, Inc., 31 East 2nd Street, Mineola, N.Y. 11501

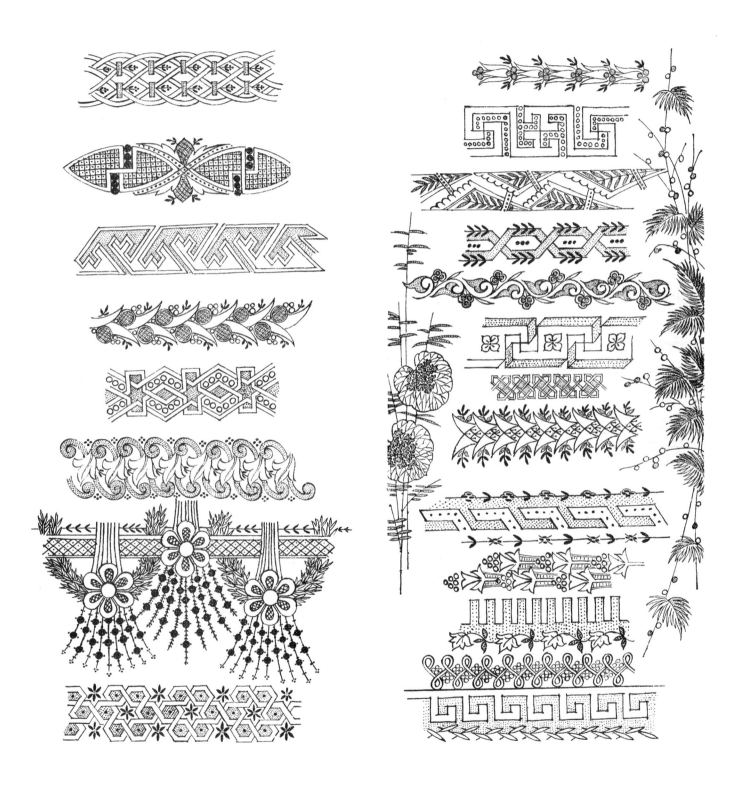

Plate 1

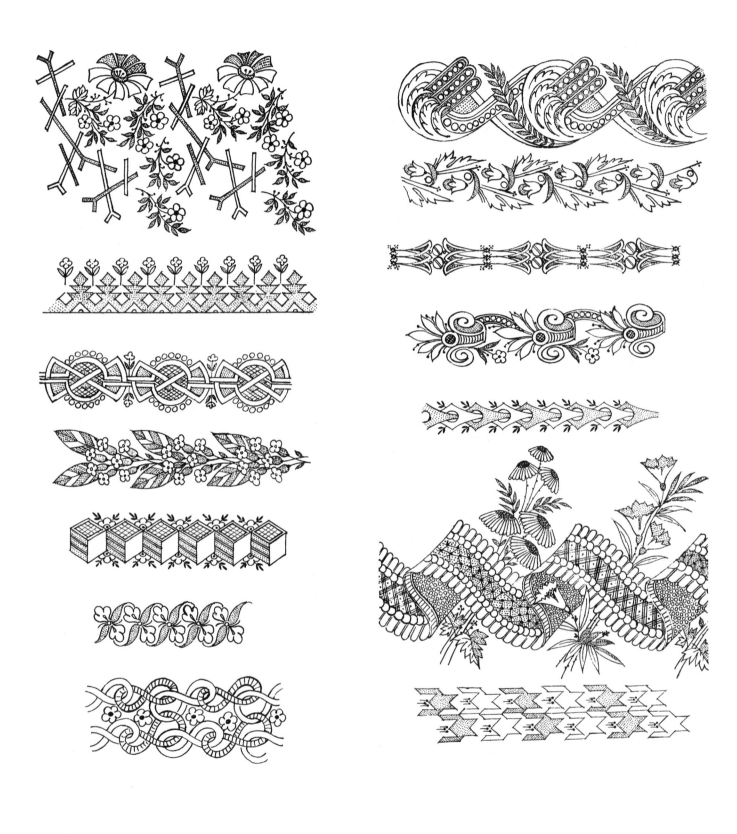

Plate 2

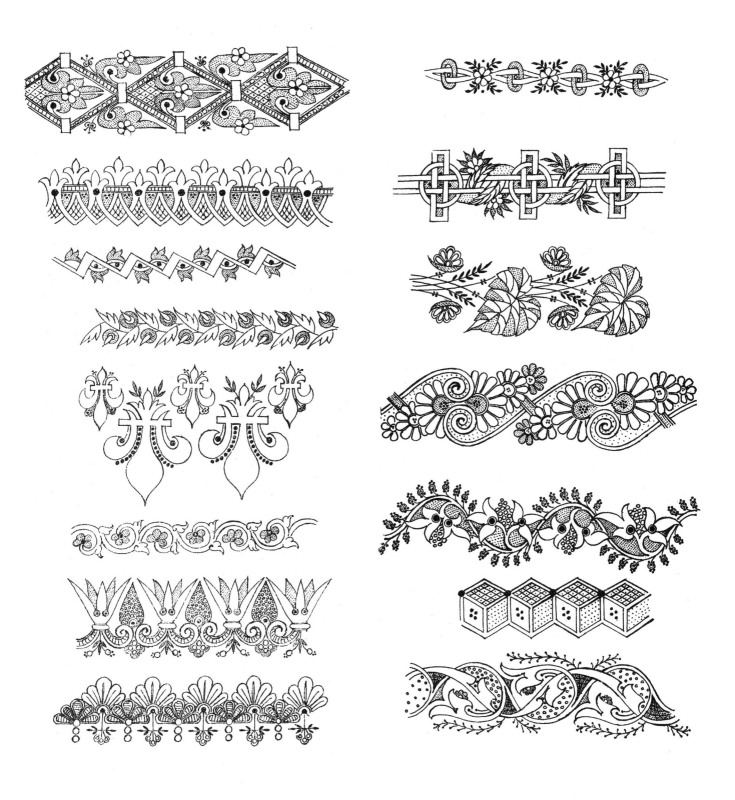

Plate 3

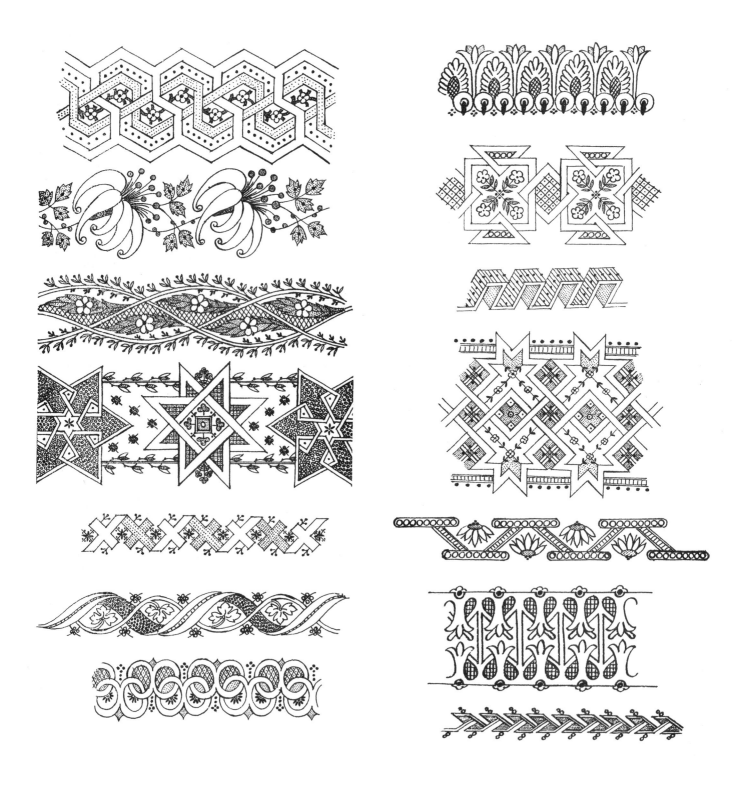

Plate 4

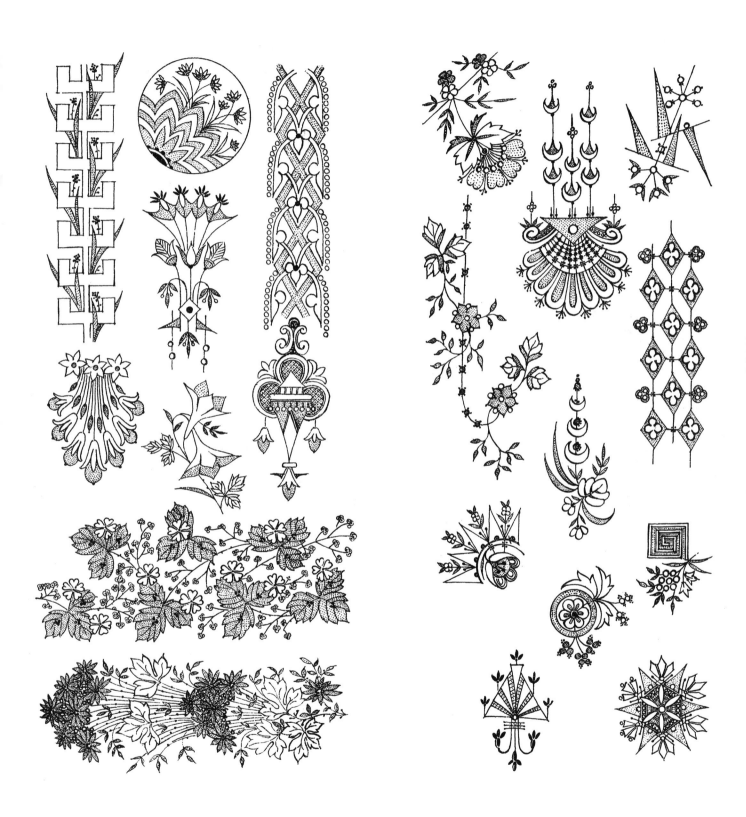

Plate 5

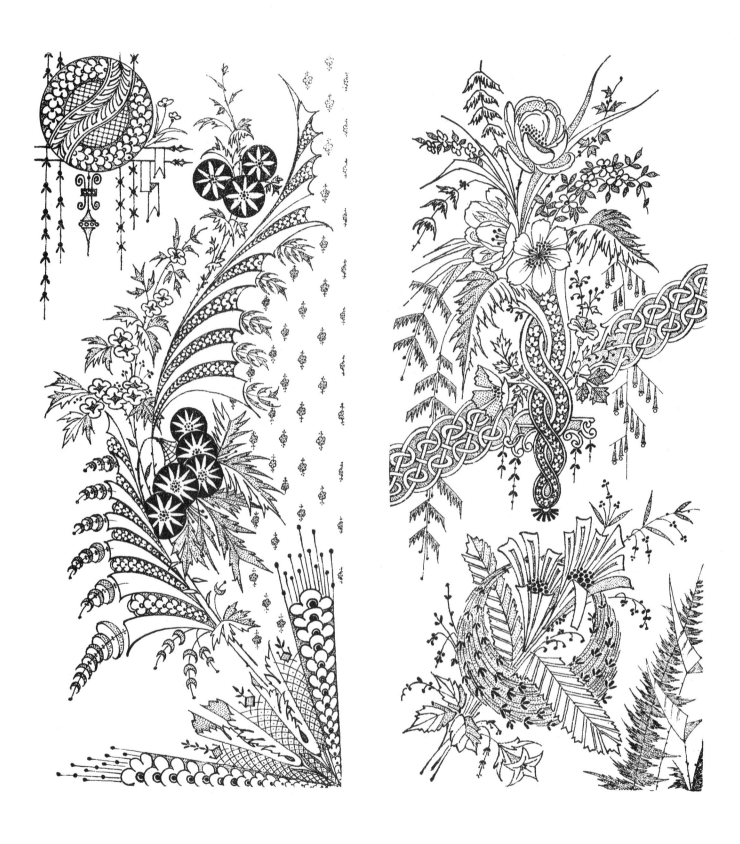

Plate 6

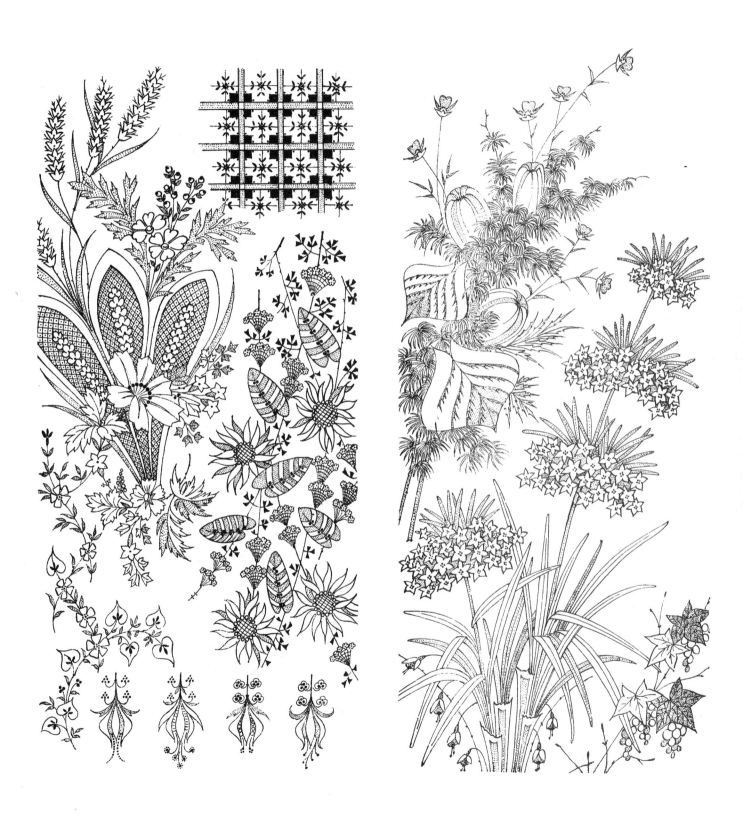

Plate 7

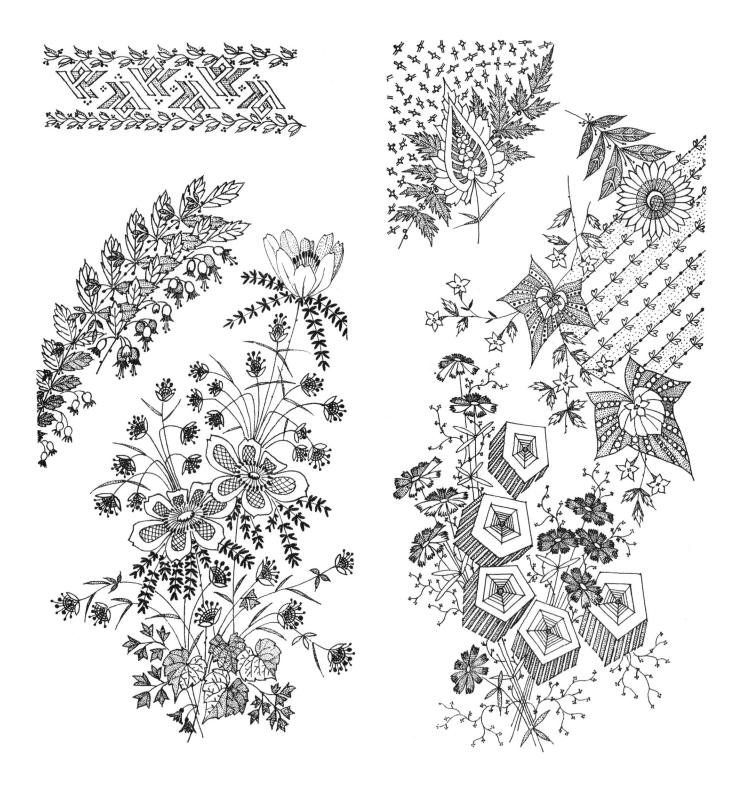

Plate 8

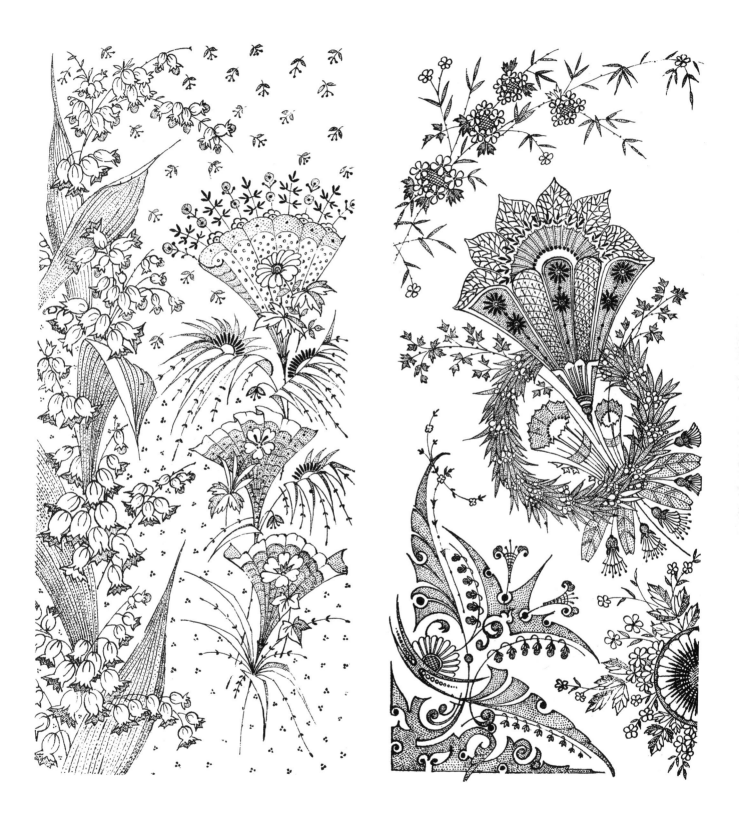

Plate 9

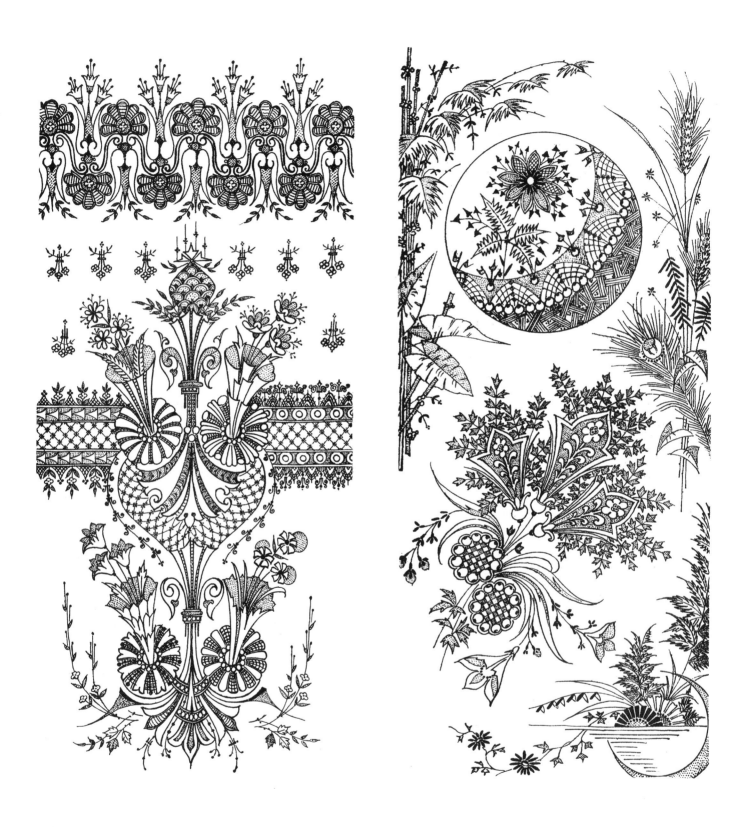

Plate 10

Plate 11

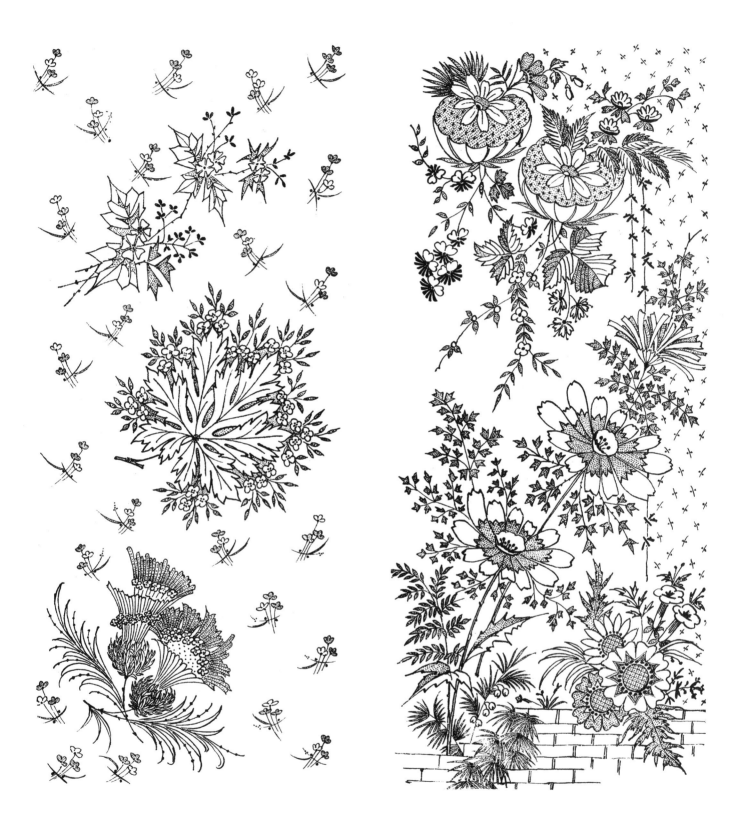

Plate 12

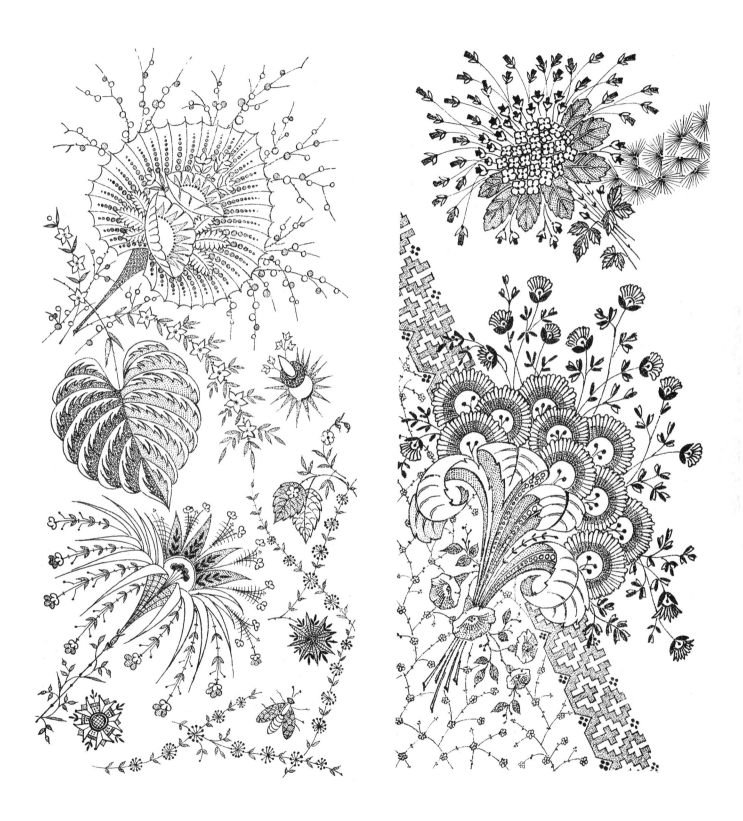

Plate 13

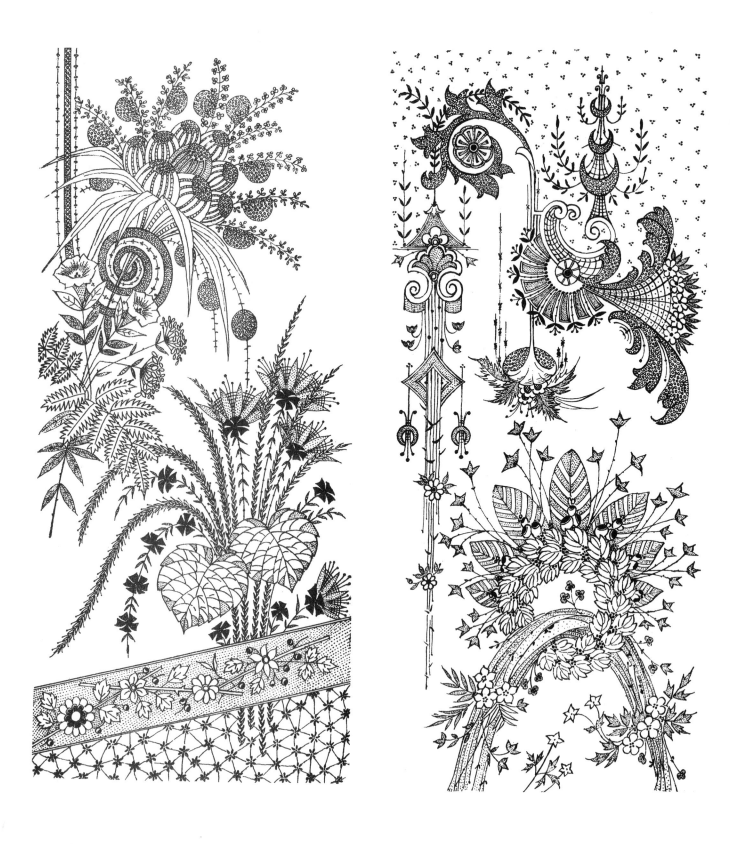

Plate 14

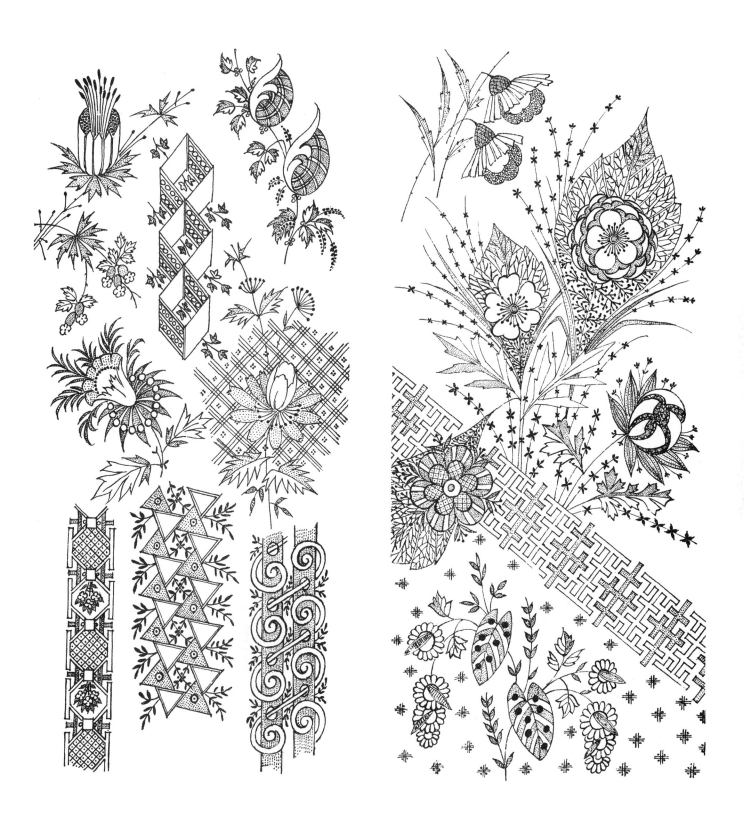

Plate 15

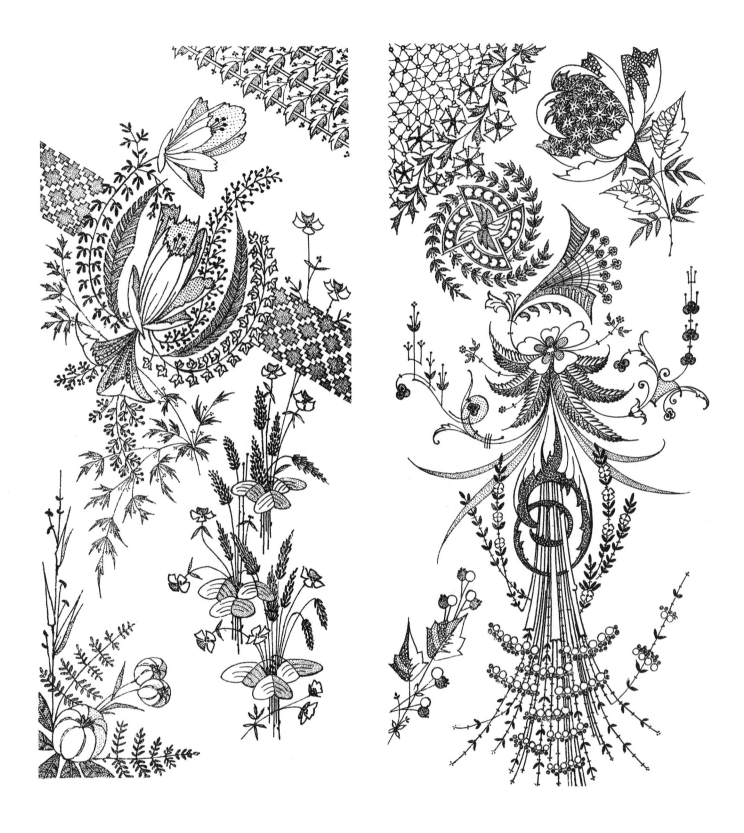

Plate 16

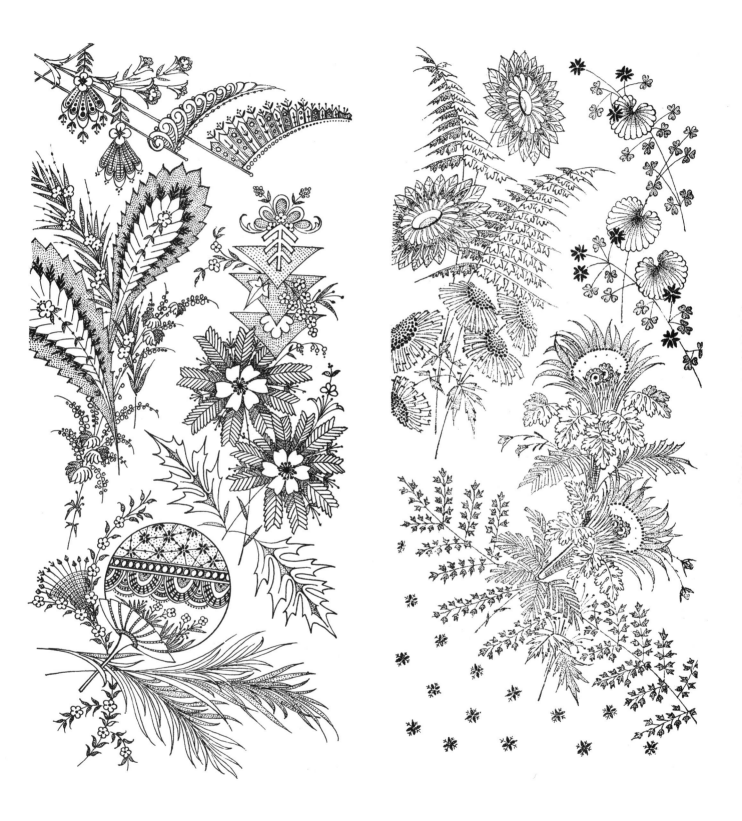

Plate 17

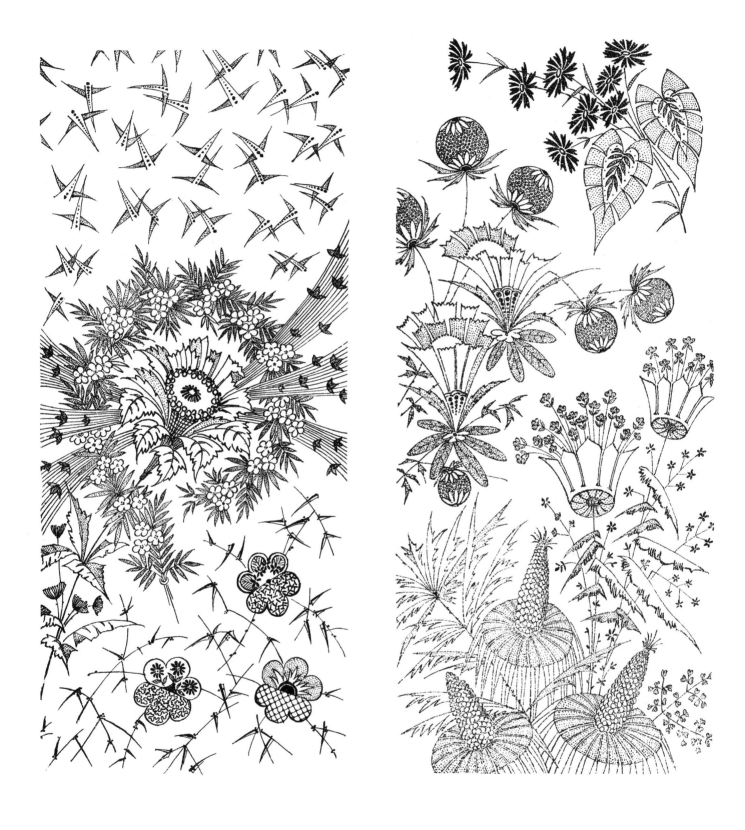

Plate 18

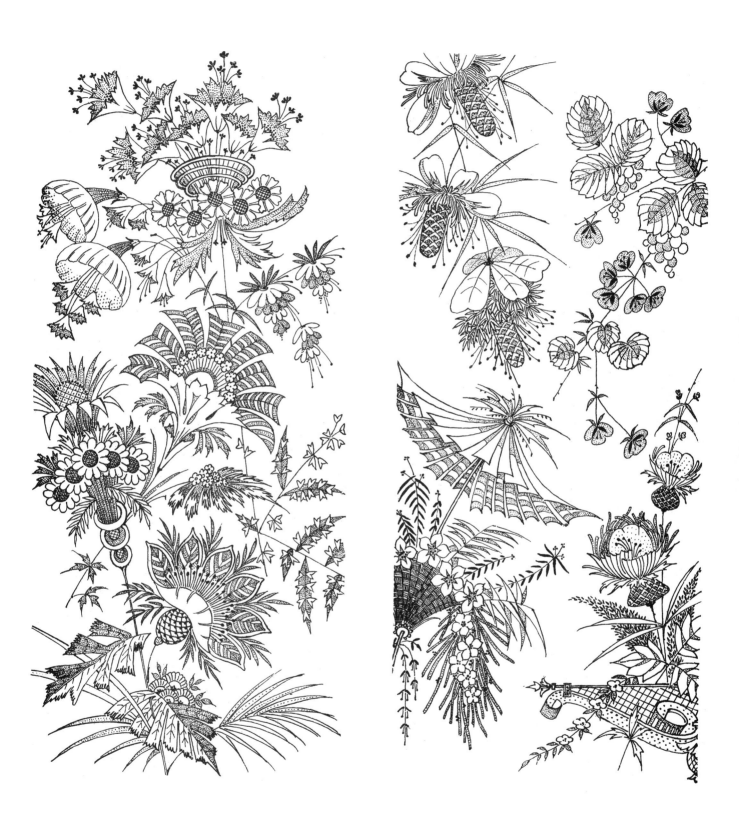

Plate 19

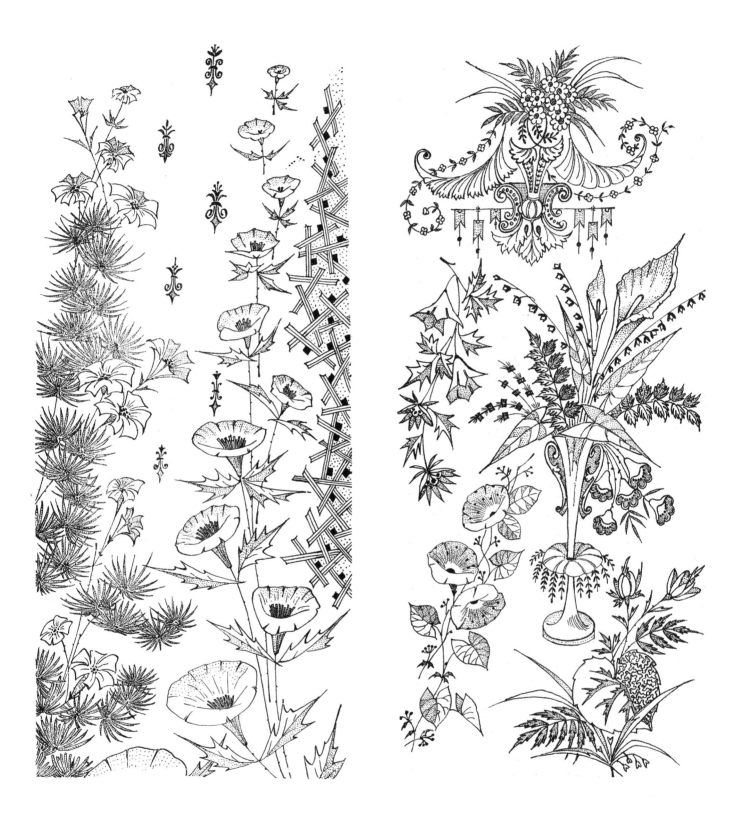

Plate 20

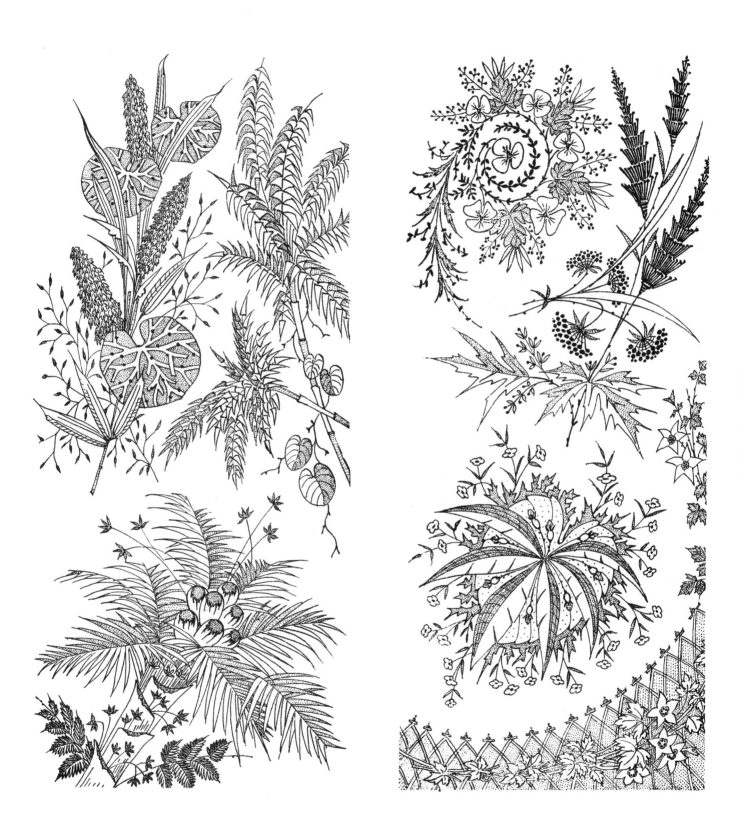

Plate 21

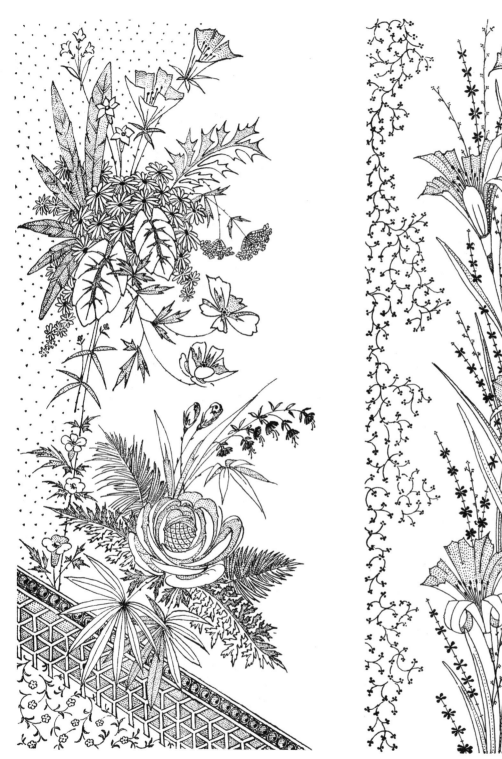
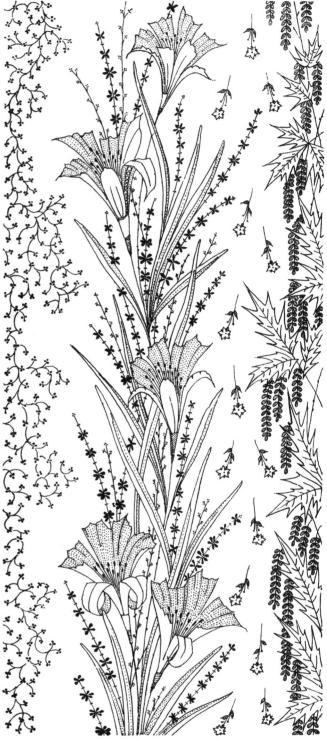

Plate 22

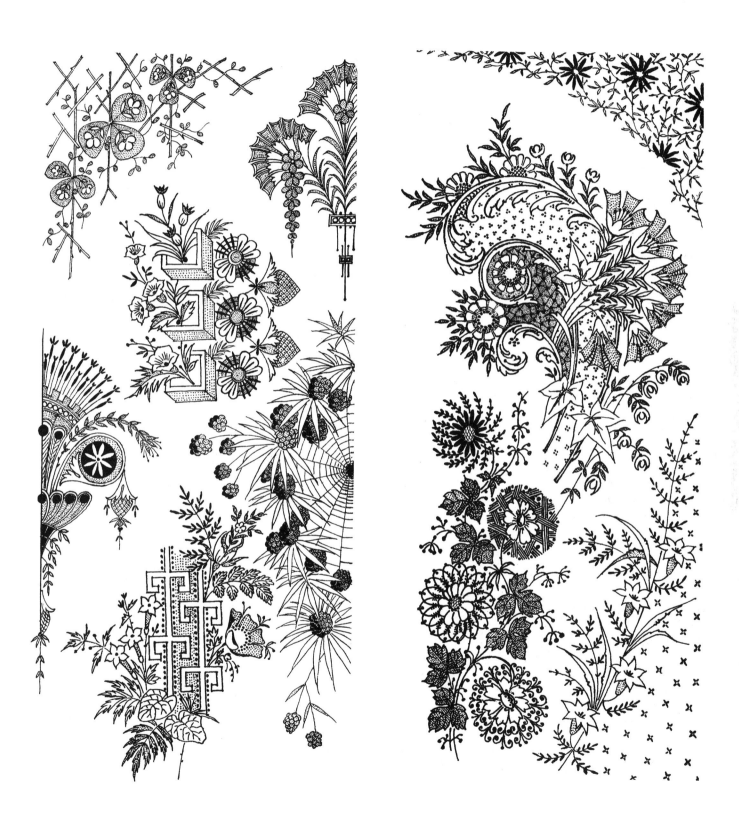

Plate 23

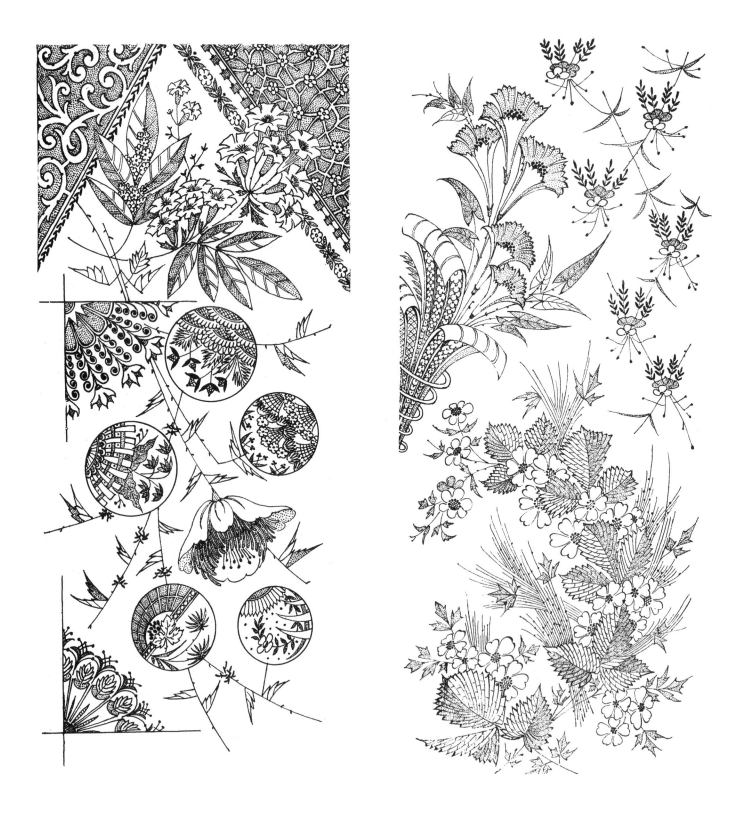

Plate 24

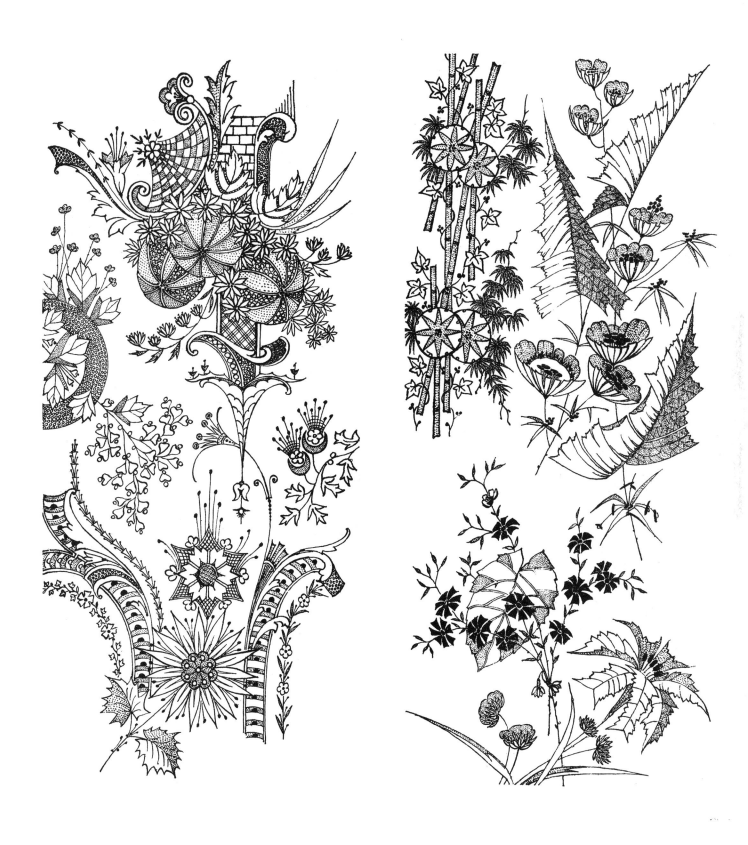

Plate 25

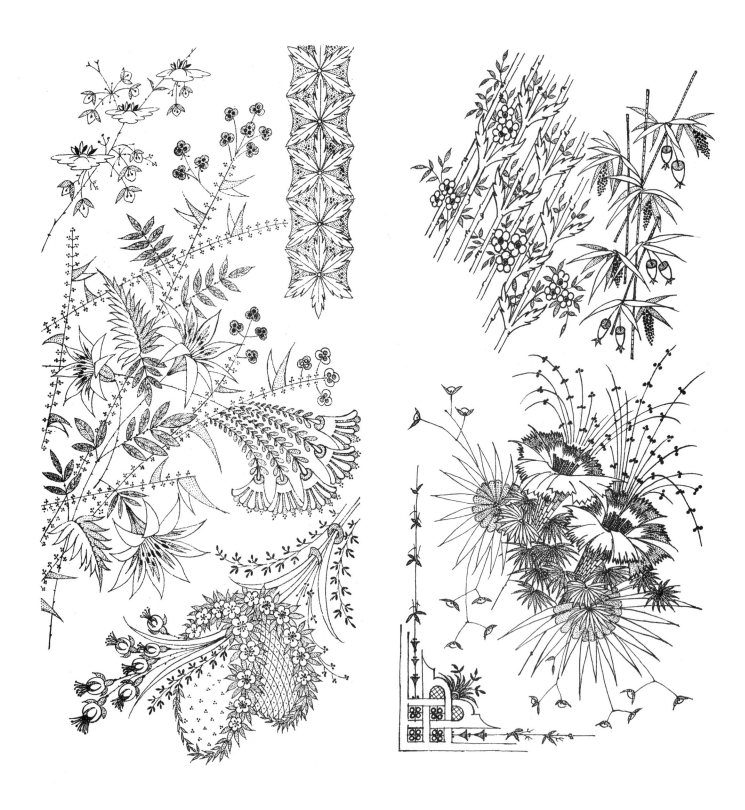

Plate 26

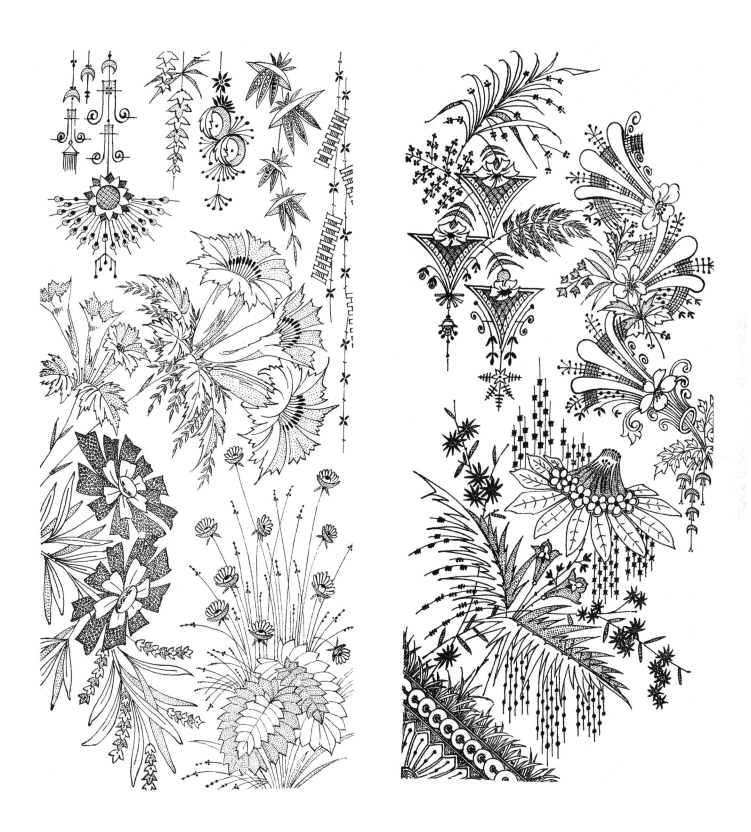

Plate 27

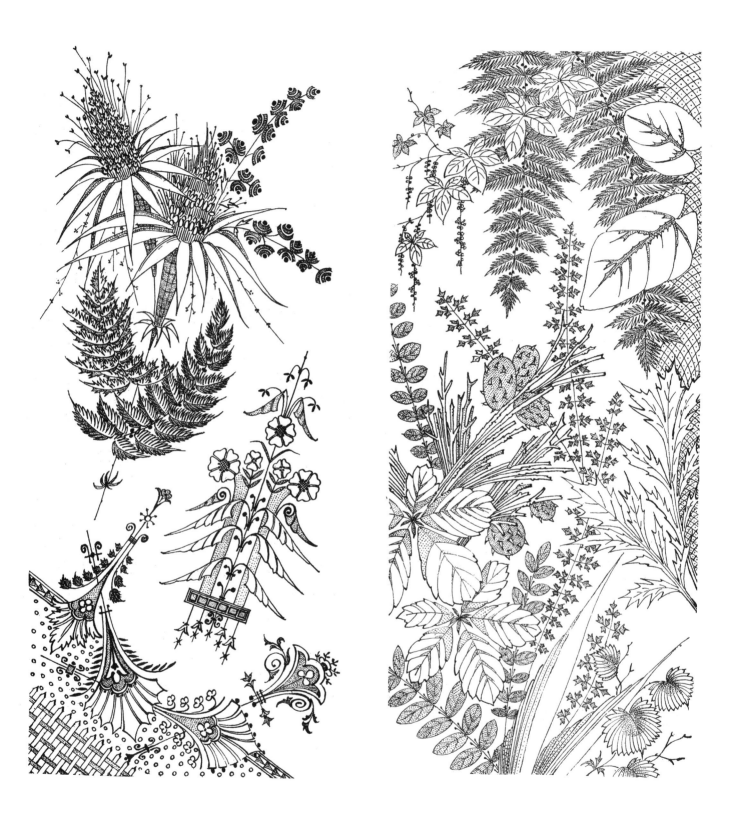

Plate 28

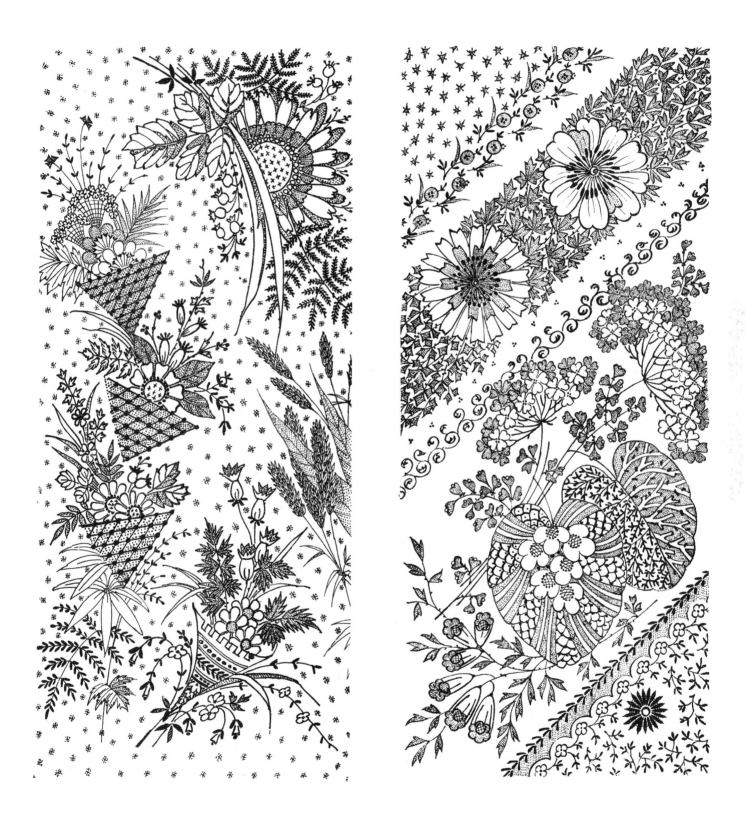

Plate 29

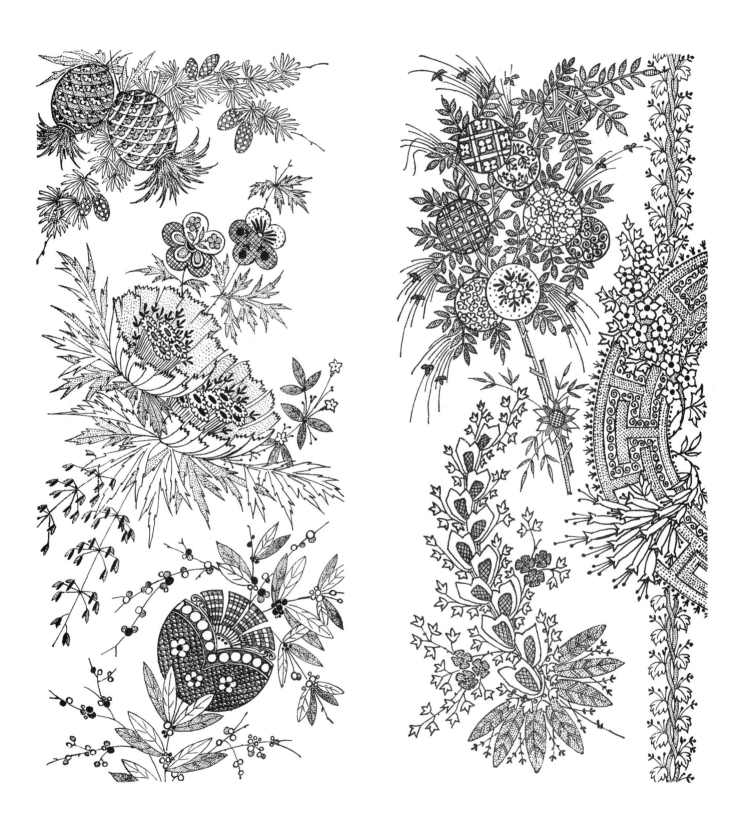

Plate 30

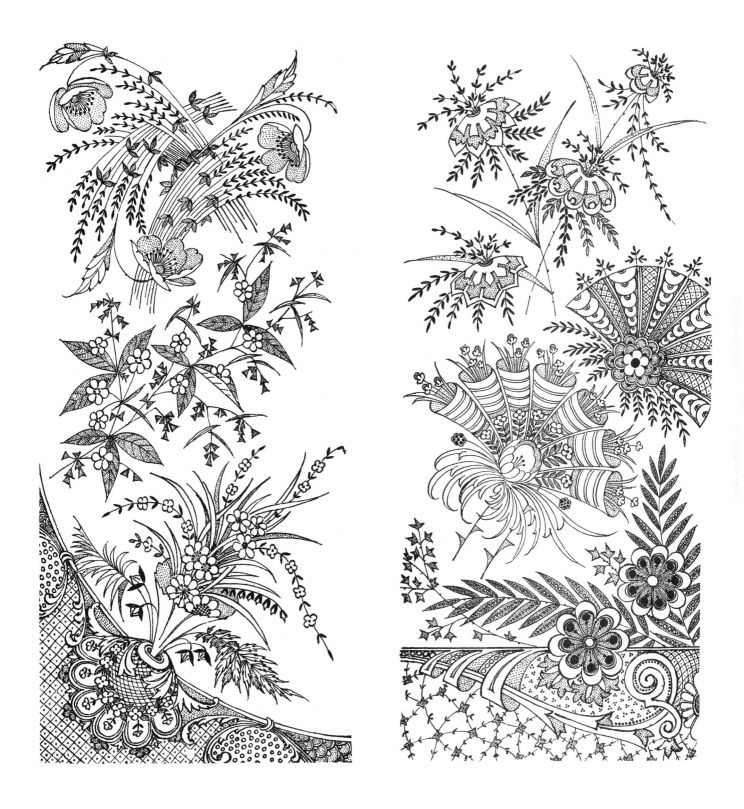

Plate 31

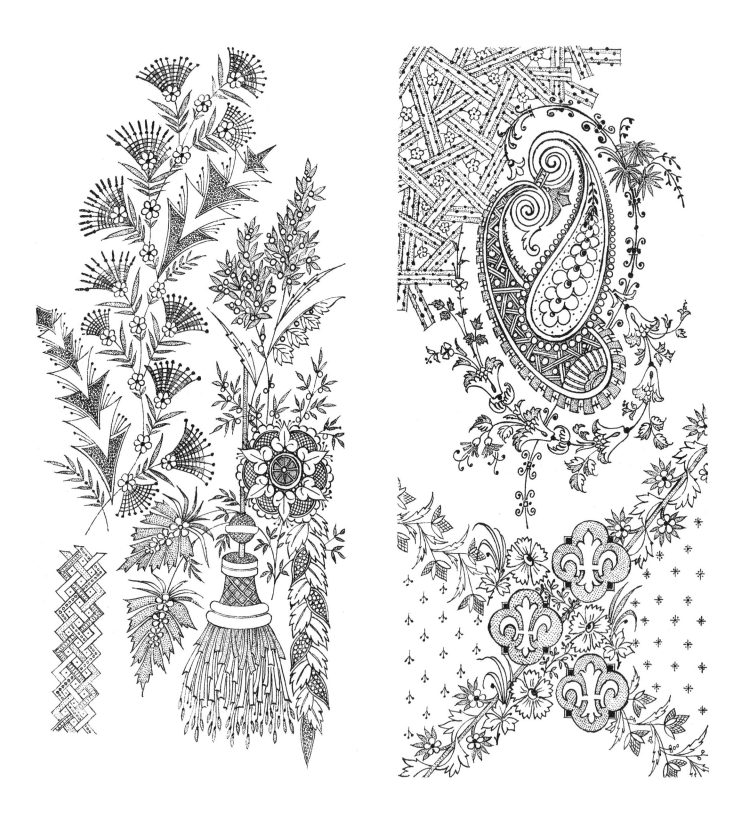

Plate 32

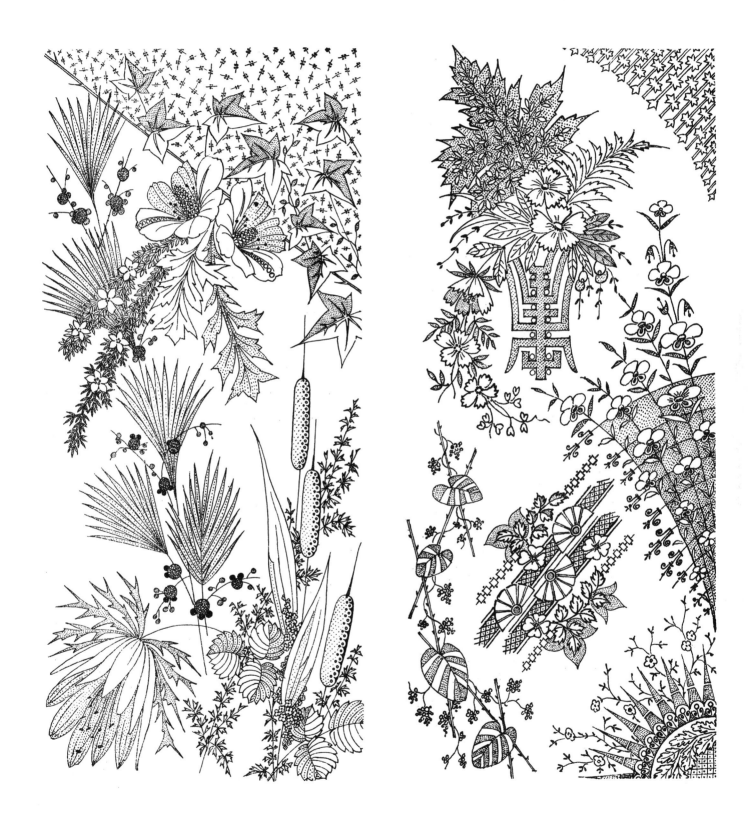

Plate 33

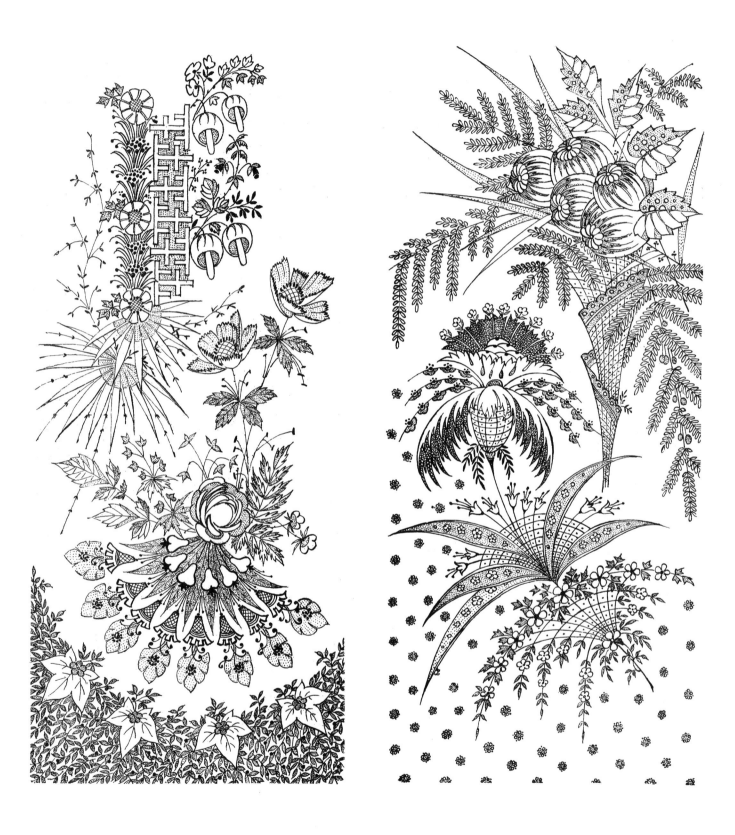

Plate 34

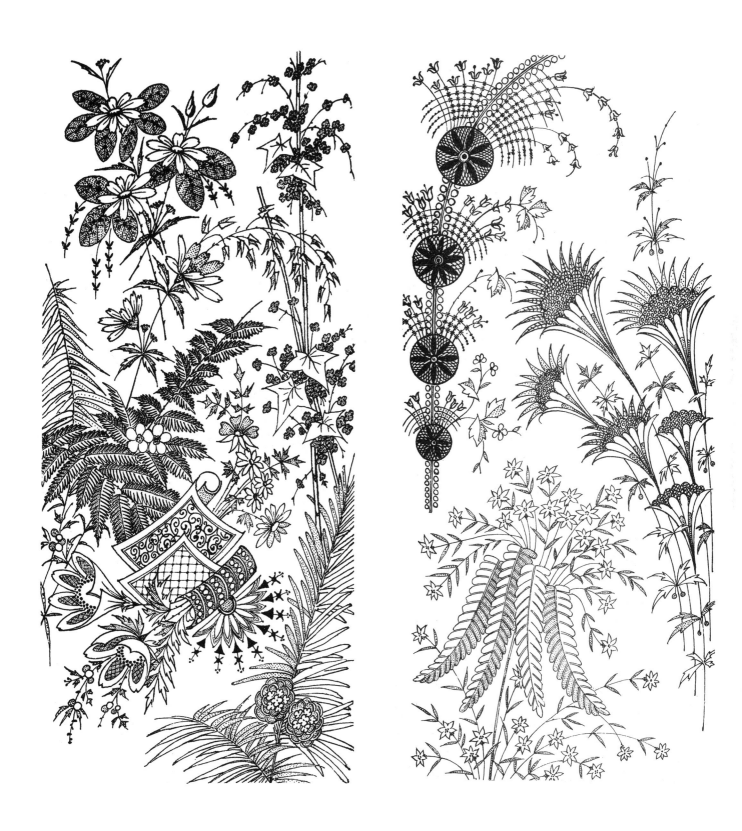

Plate 35

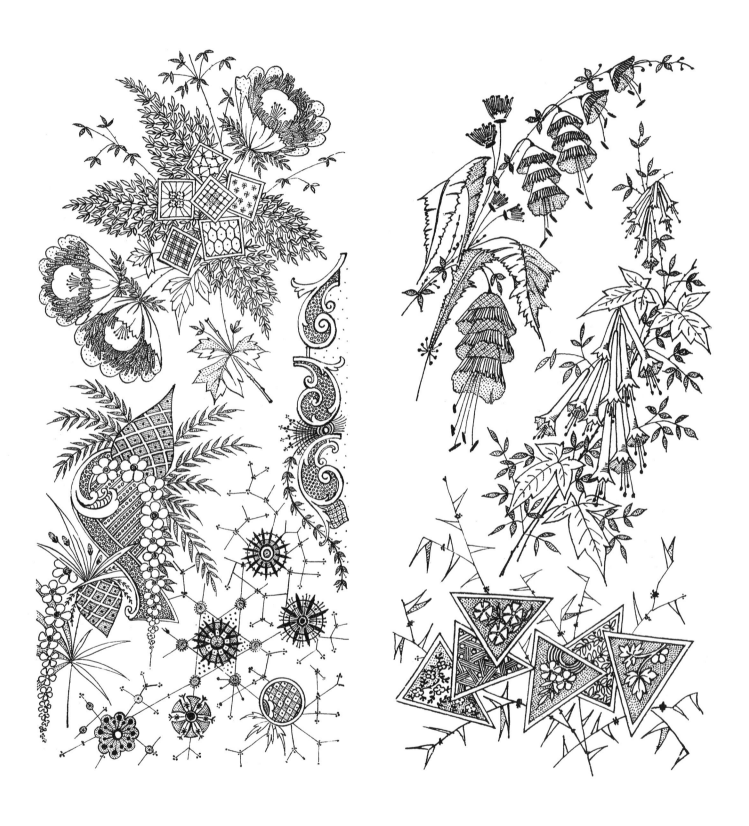

Plate 36

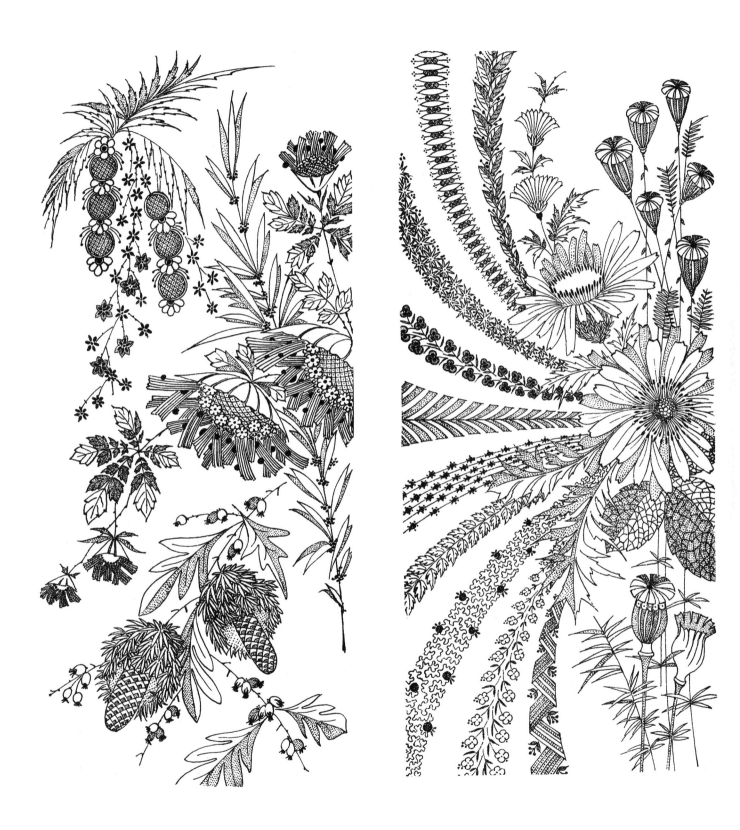

Plate 37

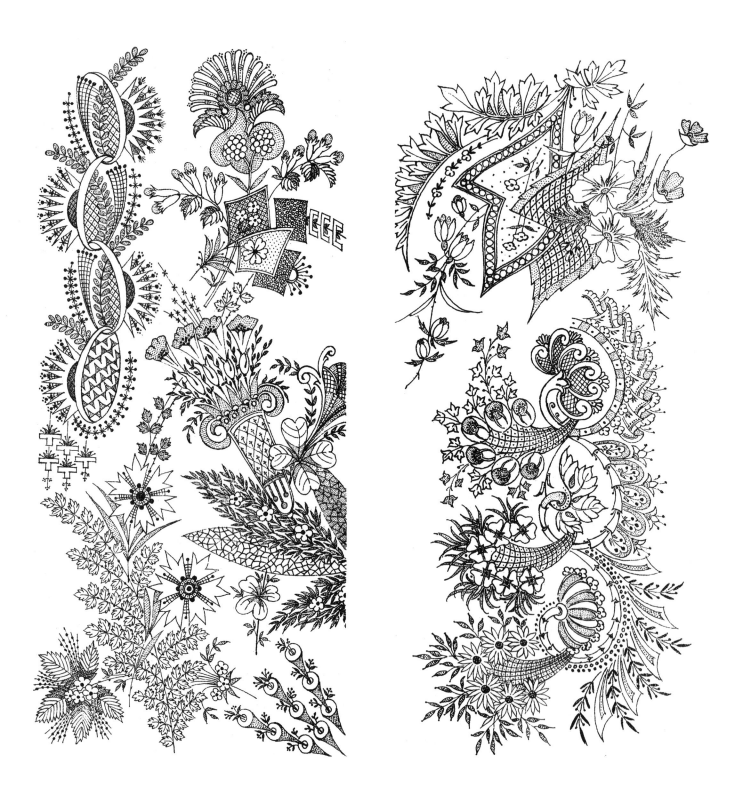

Plate 38

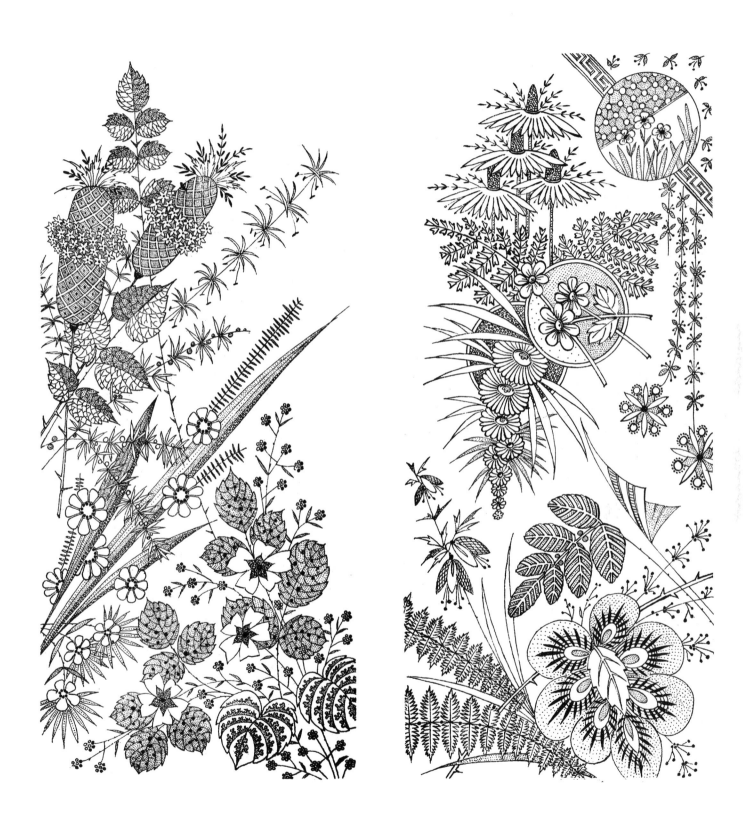

Plate 39

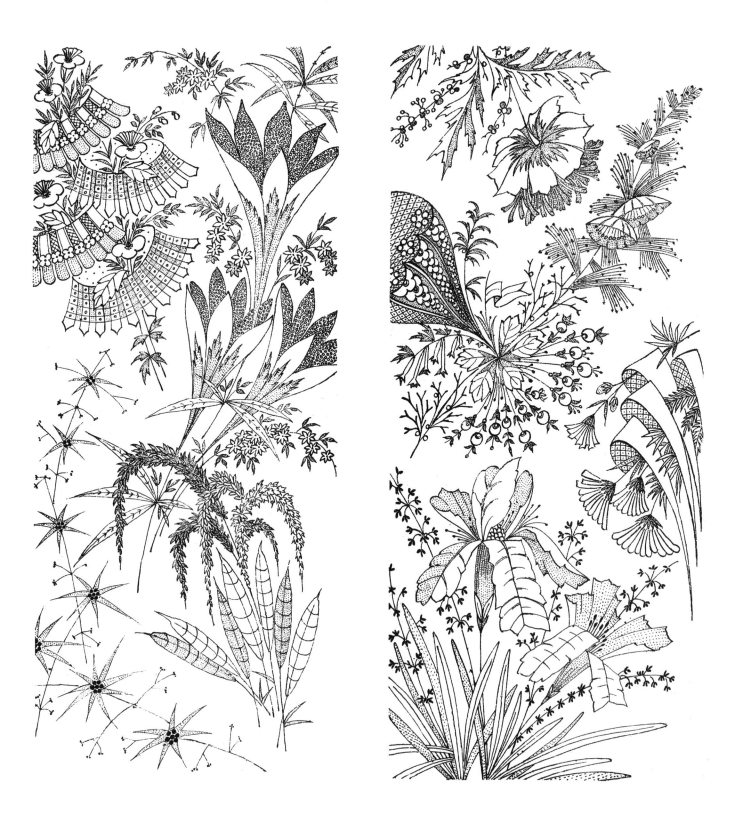

Plate 40

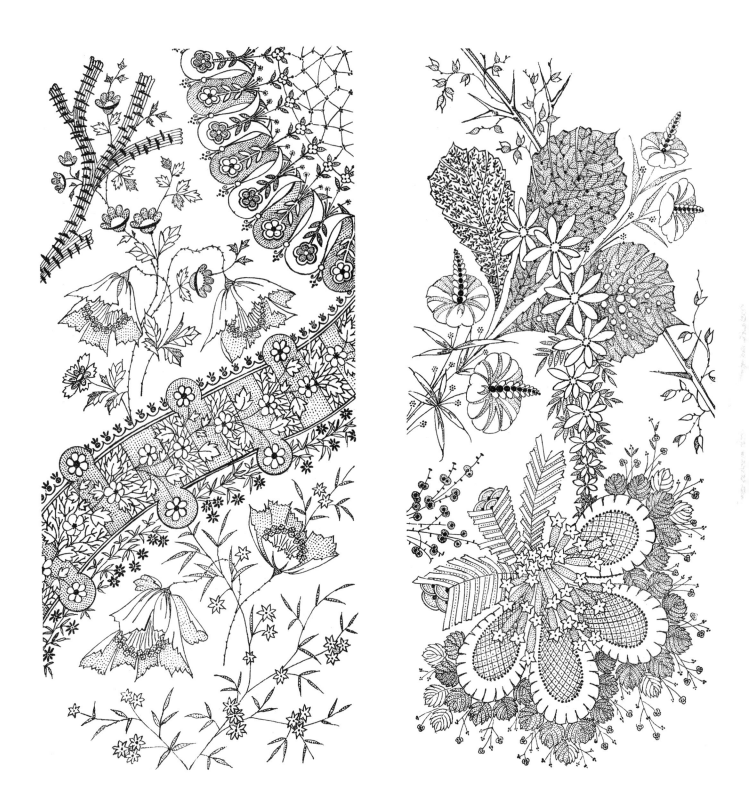

Plate 41

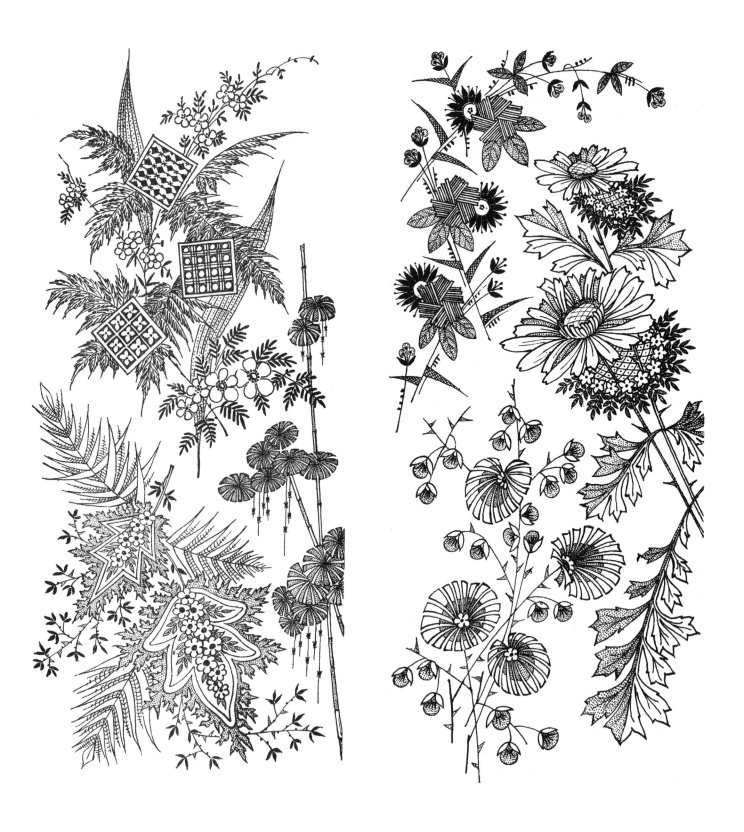

Plate 42

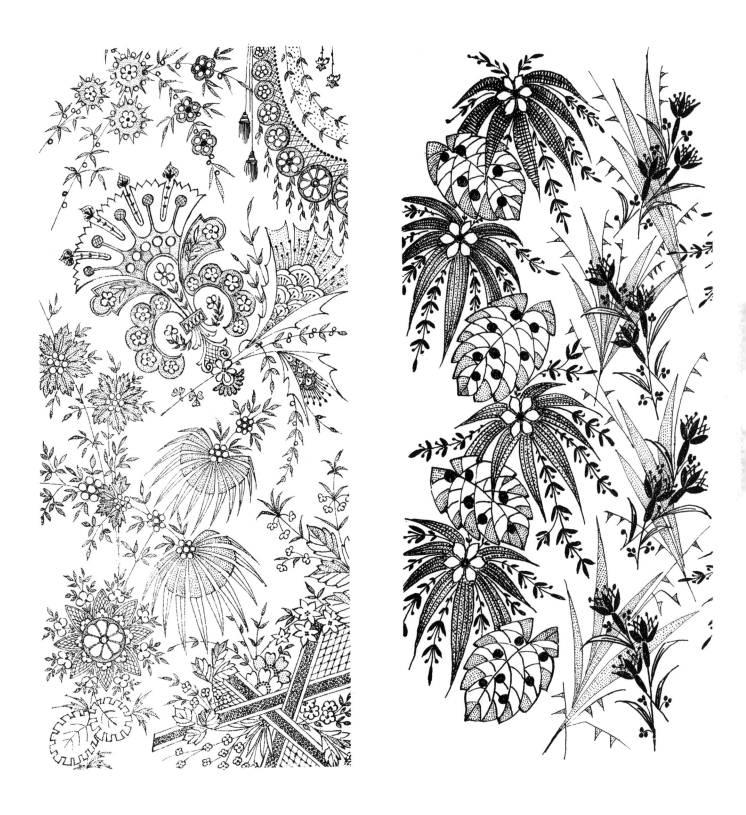

Plate 43

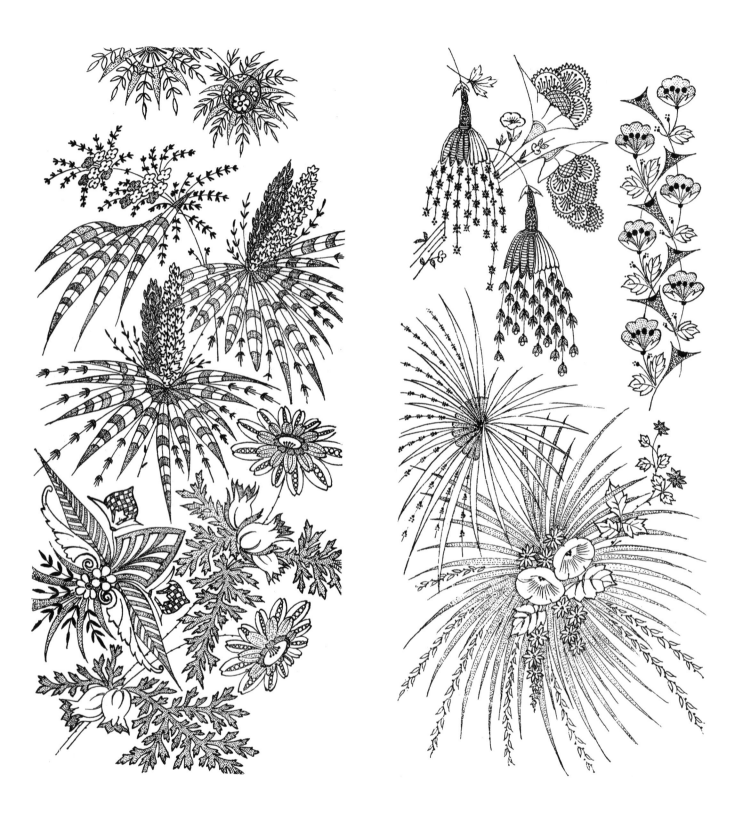

Plate 44

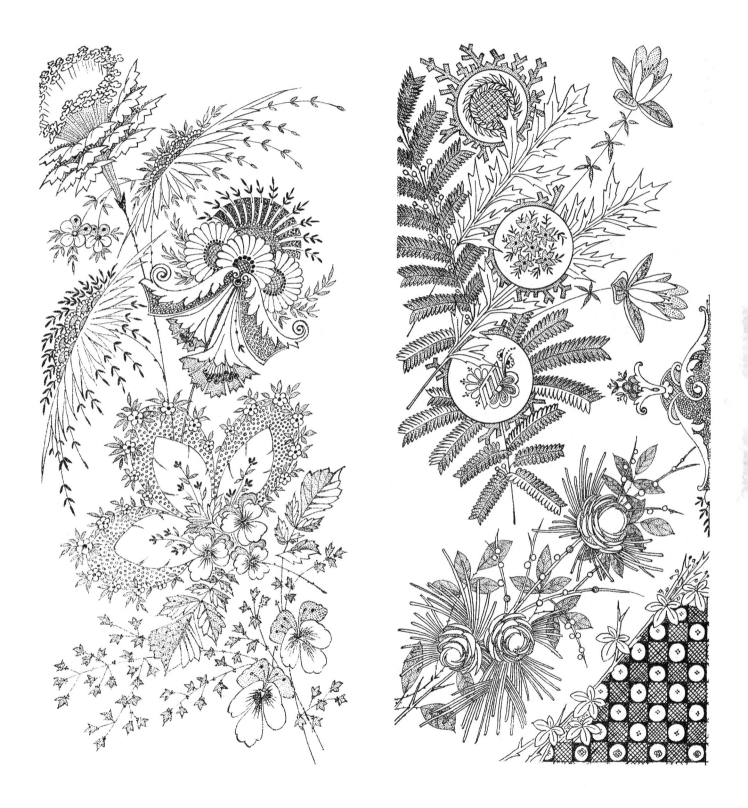

Plate 45

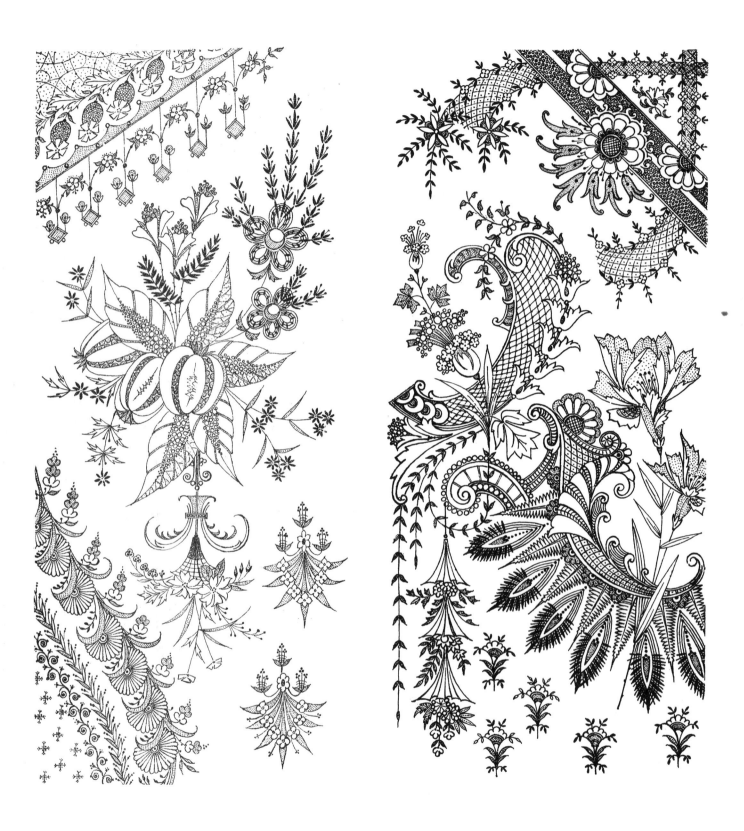

Plate 46